Trash Writings of Lucifer White

Lucifer Jeremy White

Trash Writings of Lucifer White

2019, Lucifer Jeremy White

Public Domain

All contents within are voluntarily in the public domain. Use freely.

I can be found online under my name

Lucifer Jeremy White (Damuel.)

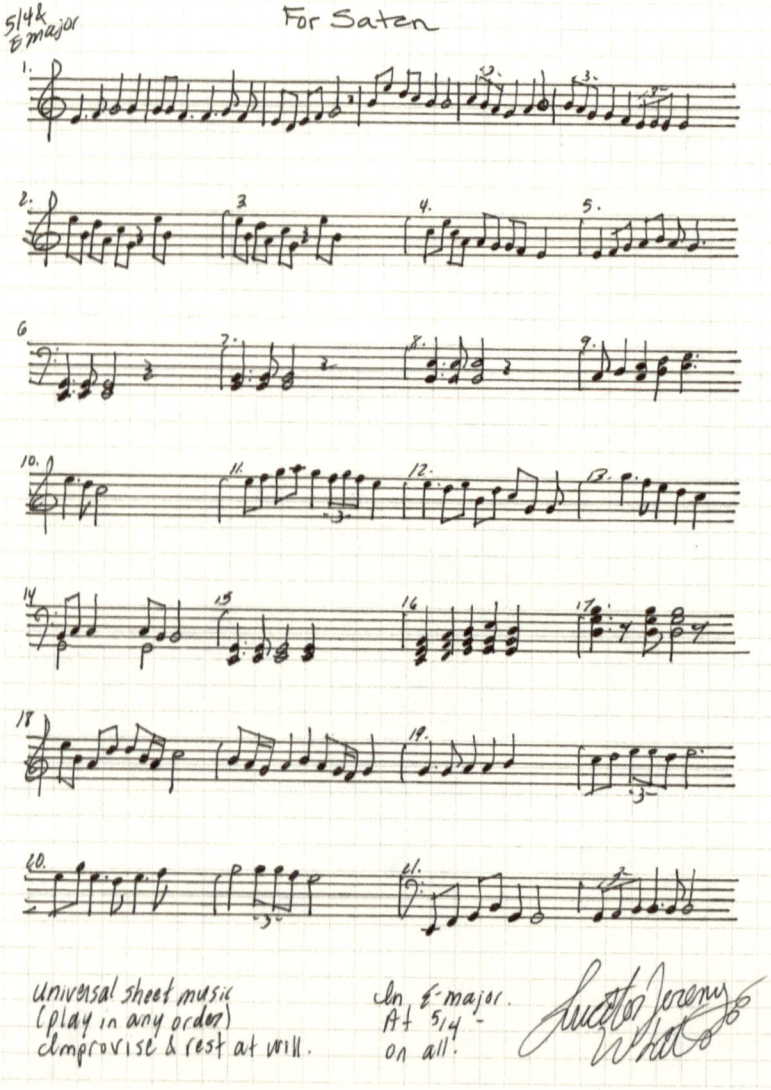

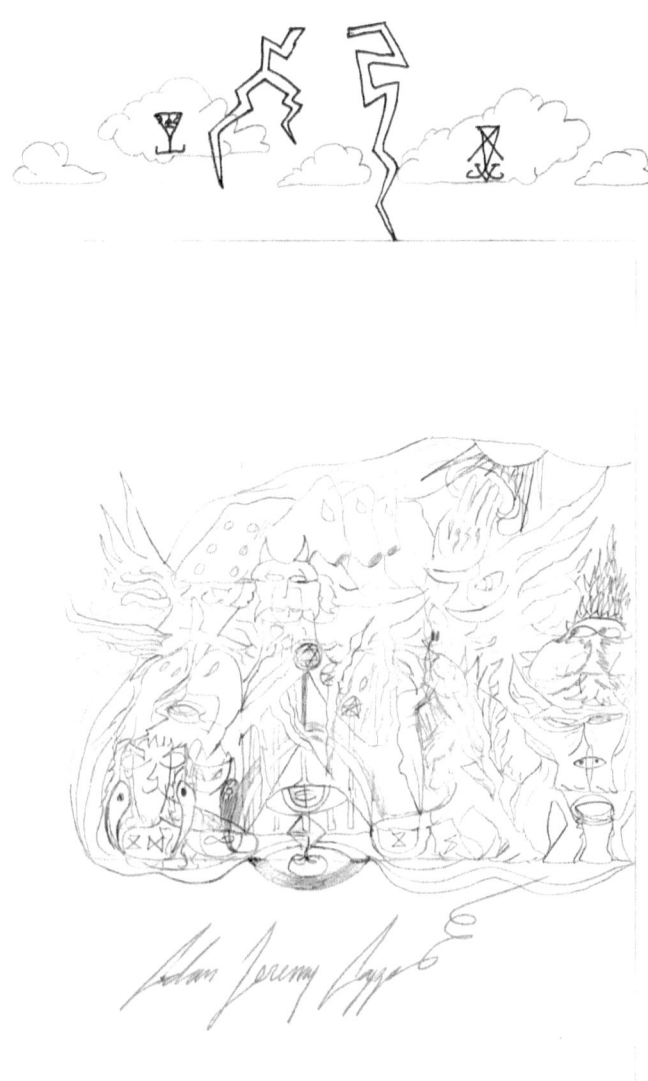

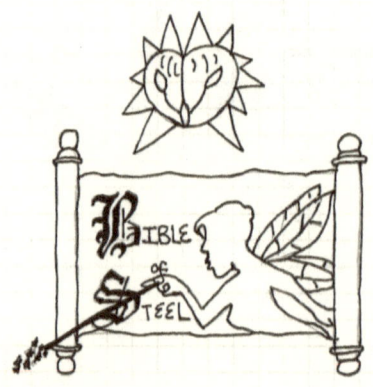

I shall work on a great book. The Bible of Steel. I shall make it both good and thick. And I do so for Lord Satan. I ask only for its success.

King Damuel

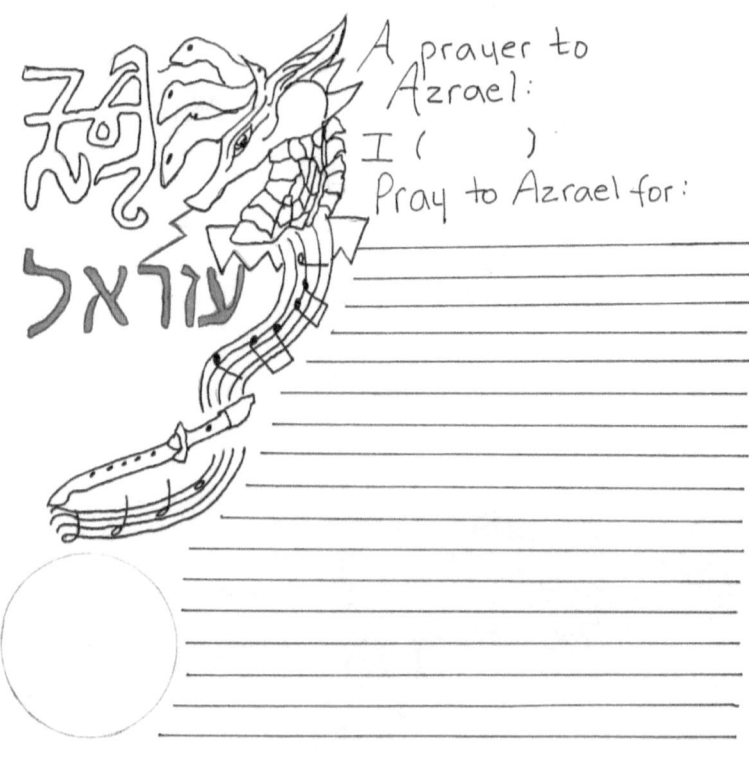

A prayer to Azrael:
I ()
Pray to Azrael for:

Signiture:

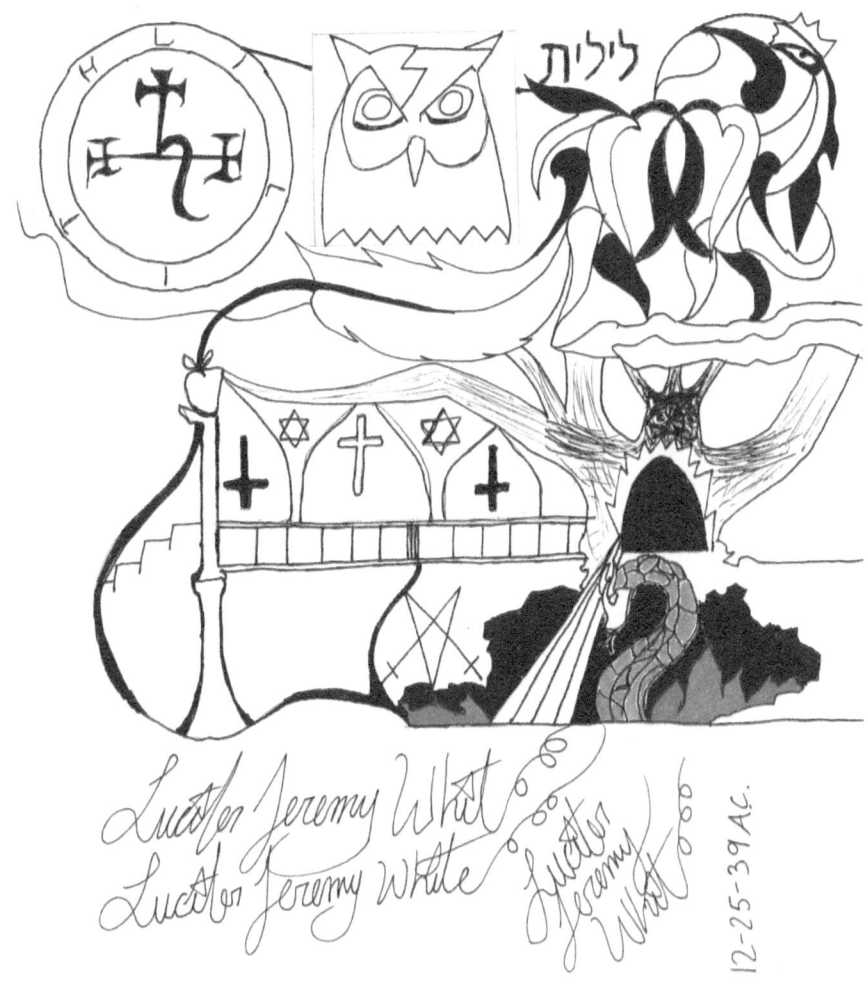

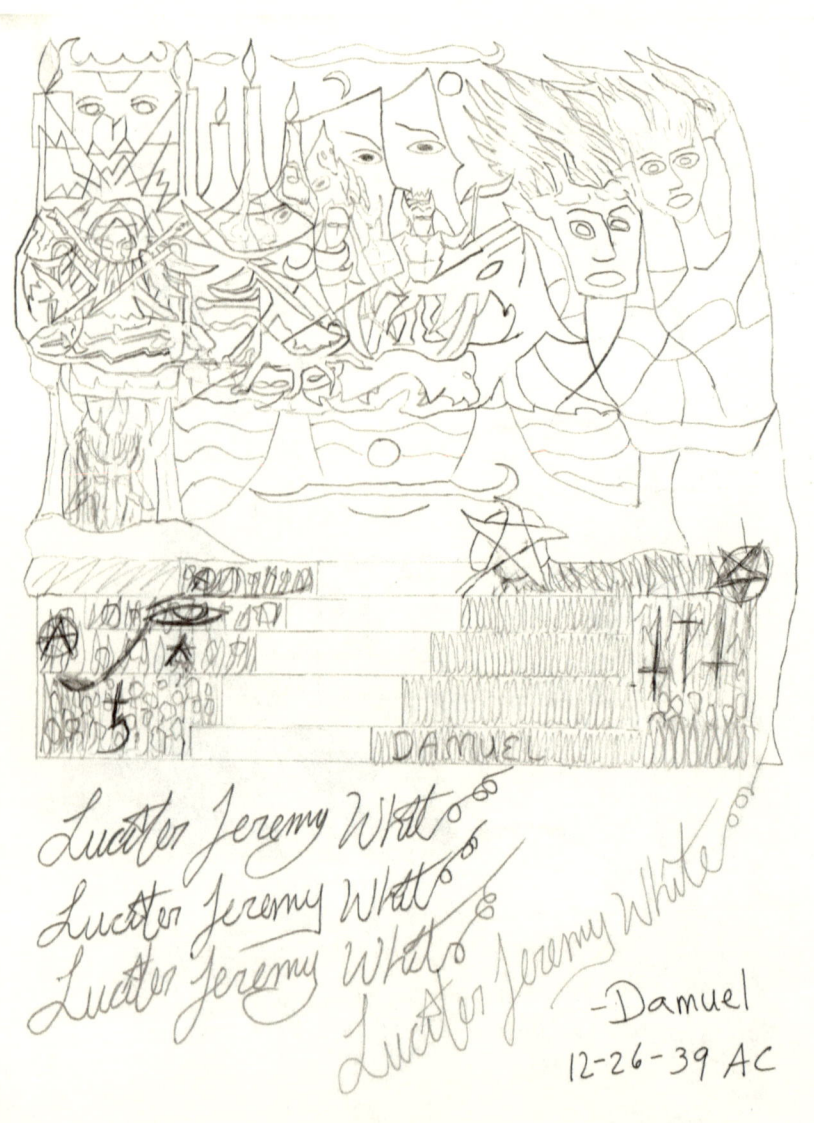

-Damuel
12-26-39 AC

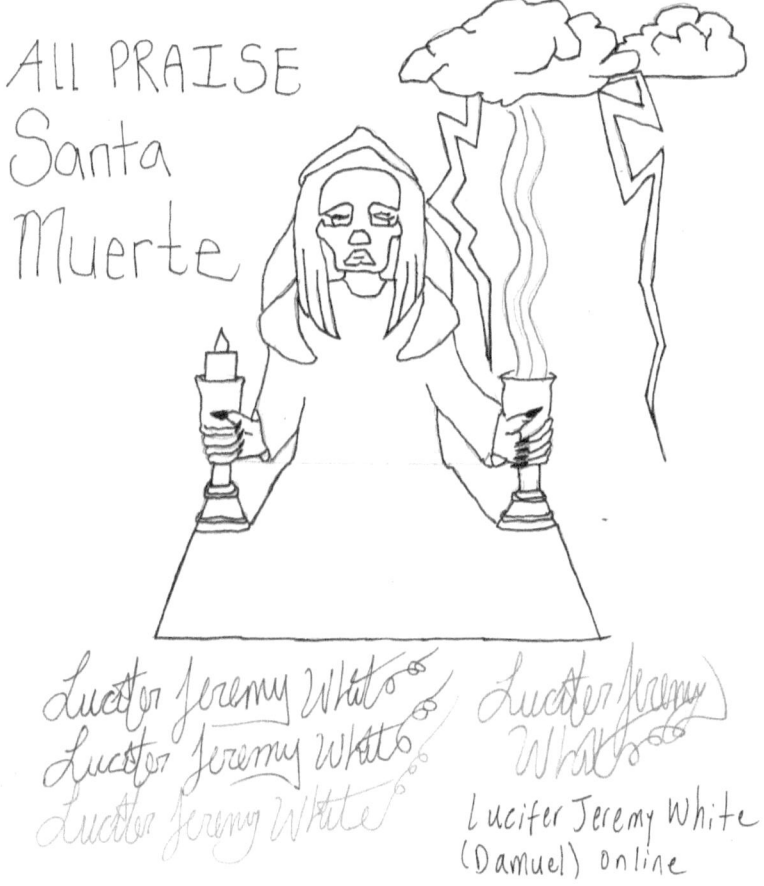

Prayer To Mammon

I () PRAY TO MAMMON FOR:

Signed: _____

Lucifer Jeremy White's
Christian Satanic Church
MEMBERSHIP CARDS
from Lucifer Jeremy White (online.)

Lucifer Jeremy White

+2 points (self)

Lucifer appoints you as a member of the Christian Satanic Church
name:

a friend through *Lucifer* appoints you as a member of the Christian Satanic Church
name:
write friend's name on back

A card of testimony. Those who can attest your worth will sign the back. When back is full of signatures, create a new card, having those signed as well. *Lucifer Jeremy White*

Business Badge
Christian Satanic Self-substantiated Leader
First prove His or Her responsibility
This card is valid — Lucifer White

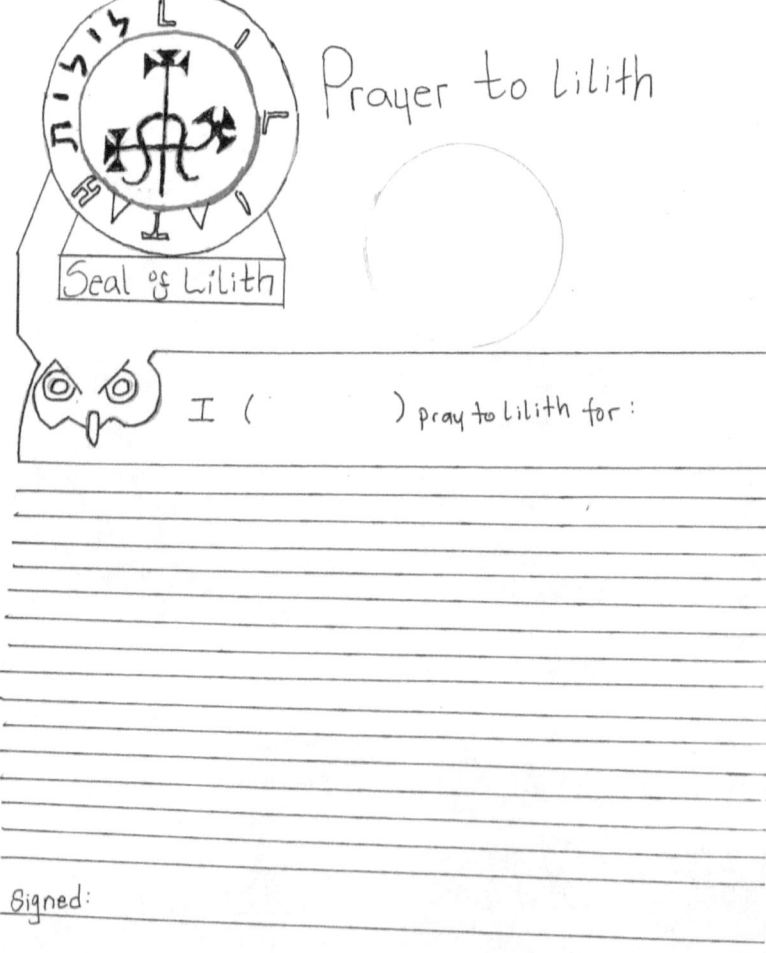

Prayer to Lilith

Seal of Lilith

I () pray to Lilith for:

Signed: _____

Lucifer Jeremy White
Lucifer Jeremy White
Lucifer Jeremy White
Lucifer Jeremy white (Damuel.)

"Finish the melody"

Lucius Jeremy White +

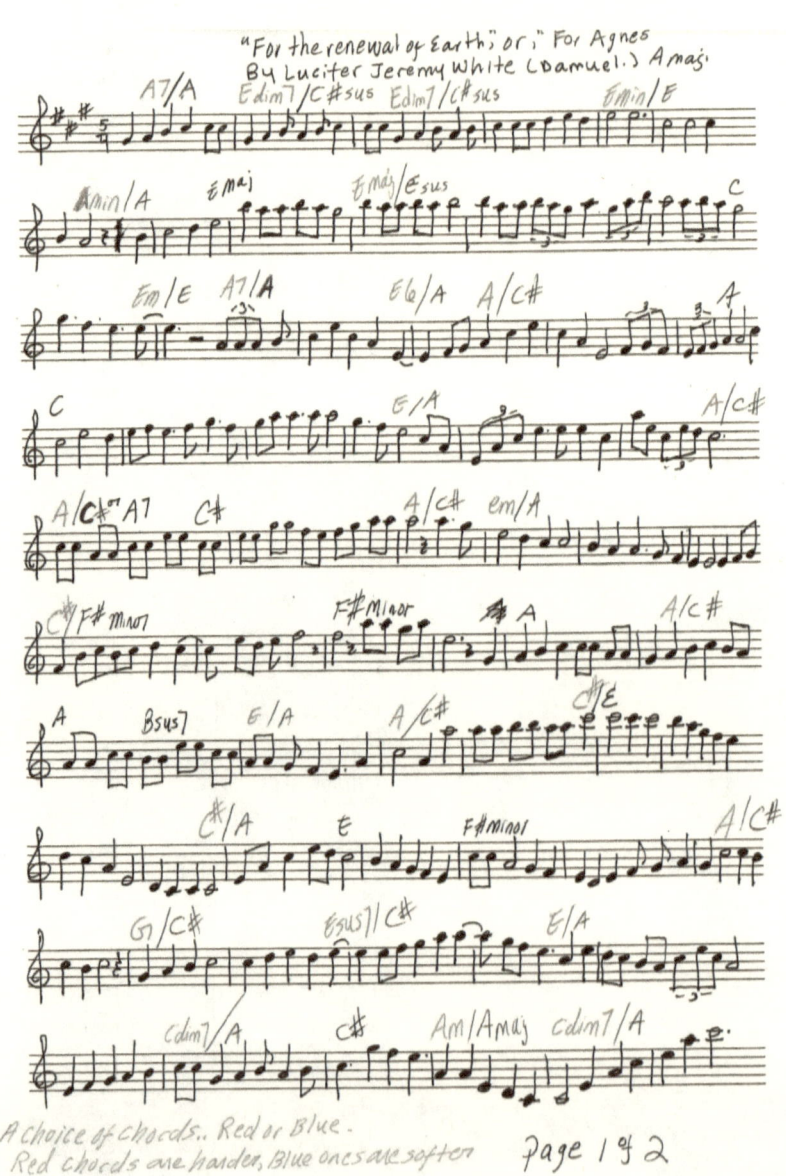

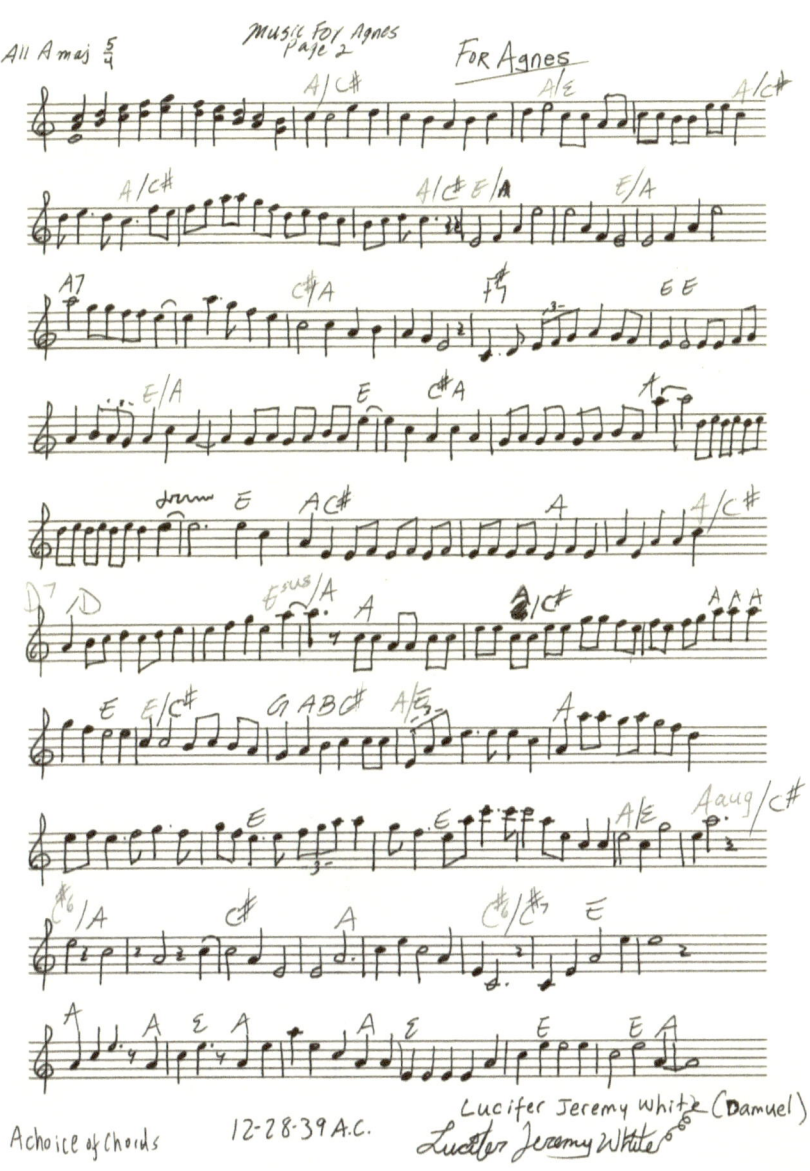

Lucifer Jeremy White (Damuel) cut-outs

```
┌─────────────────────────┐
│ Lucifer Jeremy White    │   Christian
│ Lucifer Jeremy White    │   Satanic
│ Lucifer Jeremy White    │   Church
│ Lucifer Jeremy White    │
│ Lucifer Jeremy White    │
└─────────────────────────┘
```

Lucifer Jeremy White Lucifer Jeremy White Lucifer Jeremy White Lucifer Jeremy White	Lucifer Jeremy White Lucifer Jeremy White Lucifer Jeremy White Lucifer Jeremy White	Lucifer Jeremy White Lucifer Jeremy White Lucifer Jeremy White Lucifer Jeremy W.
Lucifer Jeremy white	Lucifer Jeremy White Lucifer Jeremy White	Lucifer Jeremy Lucifer Jeremy W.
DAMUEL	DAMUEL	DAMUEL
Lucifer Jeremy White	Lucifer Jeremy White Lucifer Jeremy White Lucifer Jeremy White	⭐ WIN!
Lucifer Jeremy White Lucifer Jeremy W. Lucifer Jeremy White Lucifer J.W.	Lucifer Jeremy White Lucifer Jeremy White Lucifer Jeremy White Lucifer Jeremy White	Lucifer Jeremy White Lucifer Jeremy White Lucifer Jeremy White Lucifer Jeremy White

Matching blocks are your partner of the day
DAMUEL cards = donate something
Star card = recieve that donation

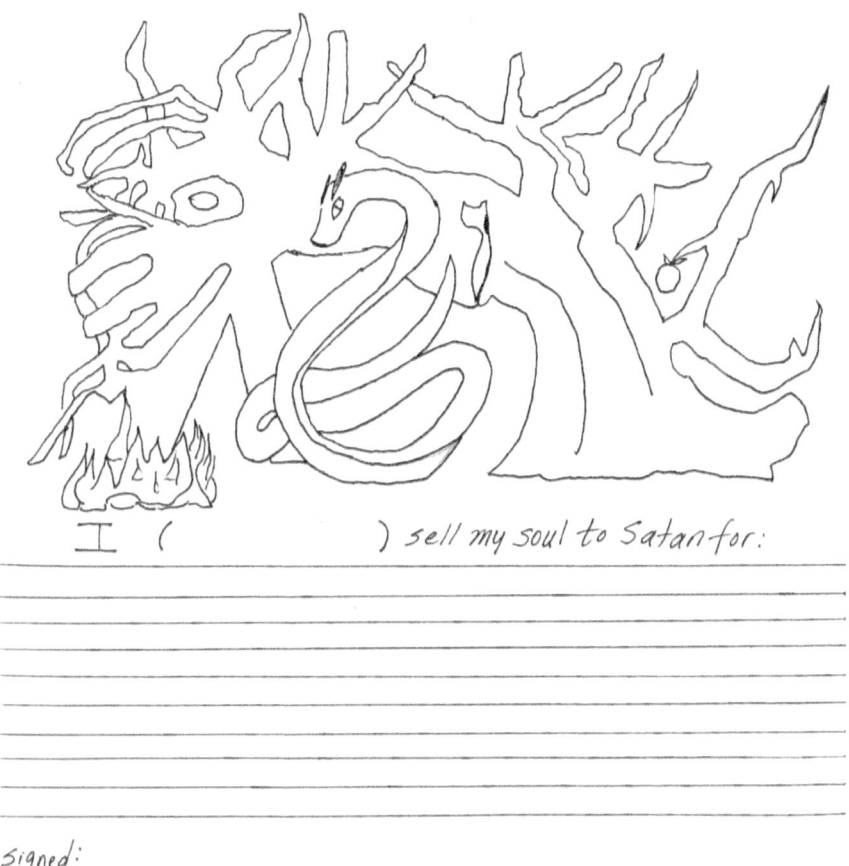

I () sell my soul to Satan for:

Signed:

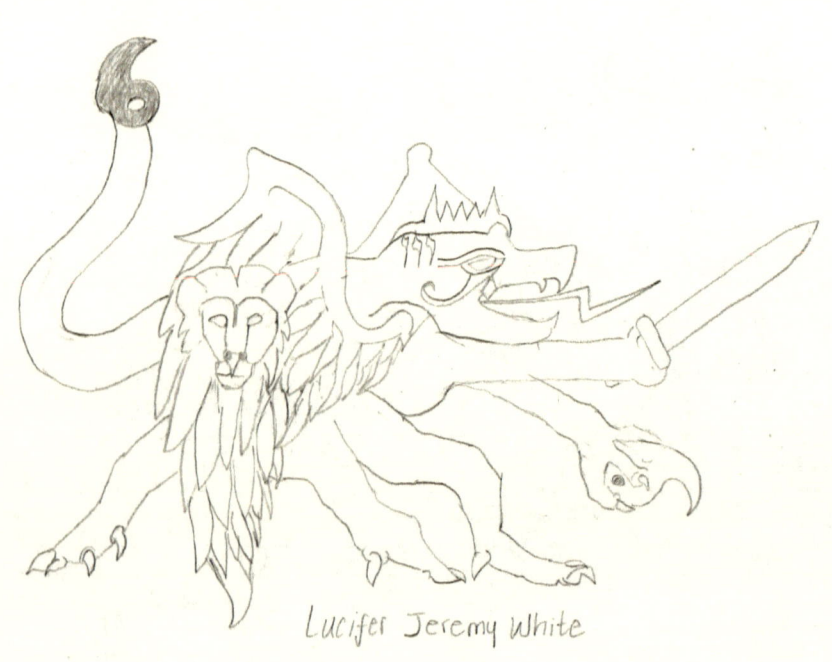

I Love Rinoa

Lucifer Jeremy White
Lucifer Jeremy White
Lucifer Jeremy White

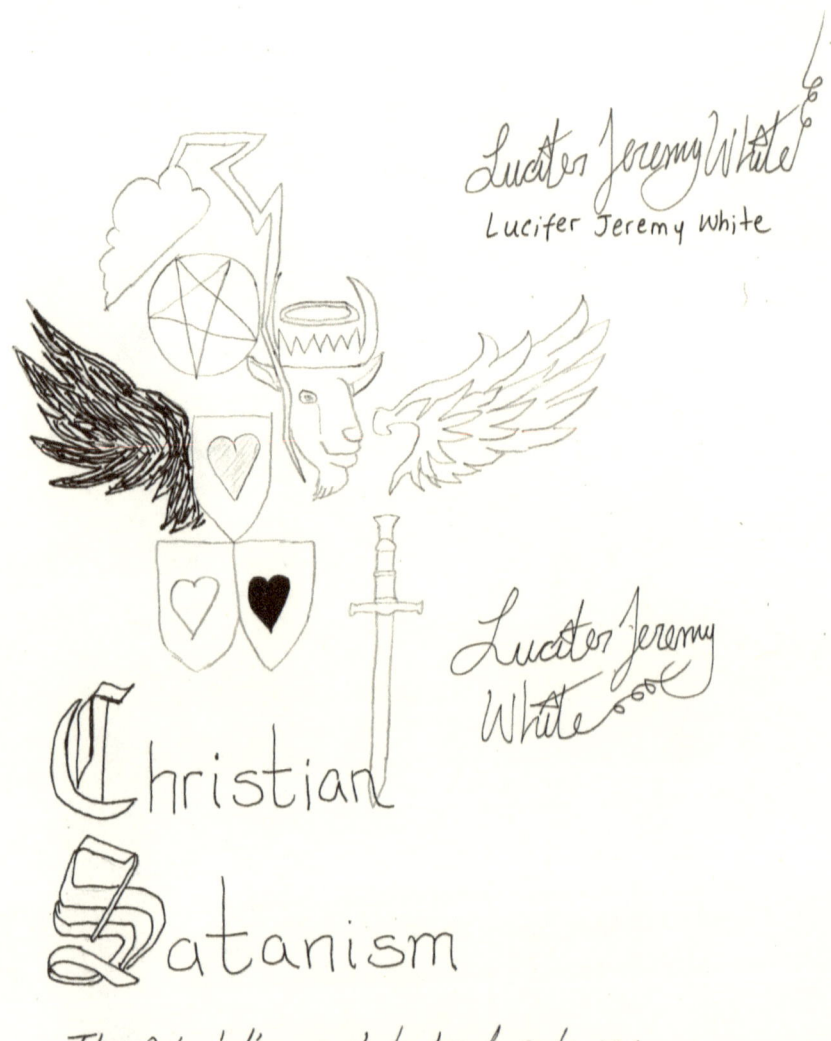

The Christian Satanic Tarot

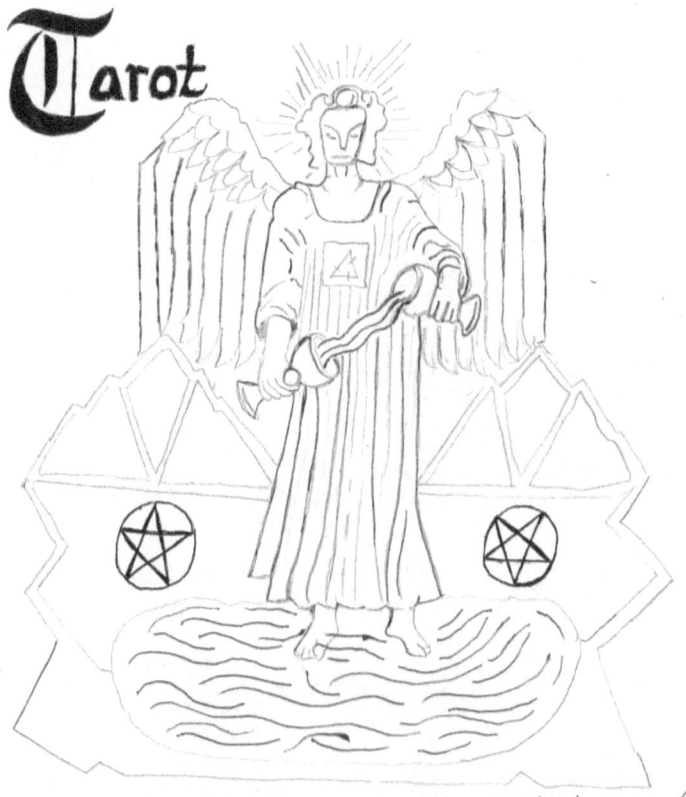

TEMPERANCE

Lucifer Jeremy White

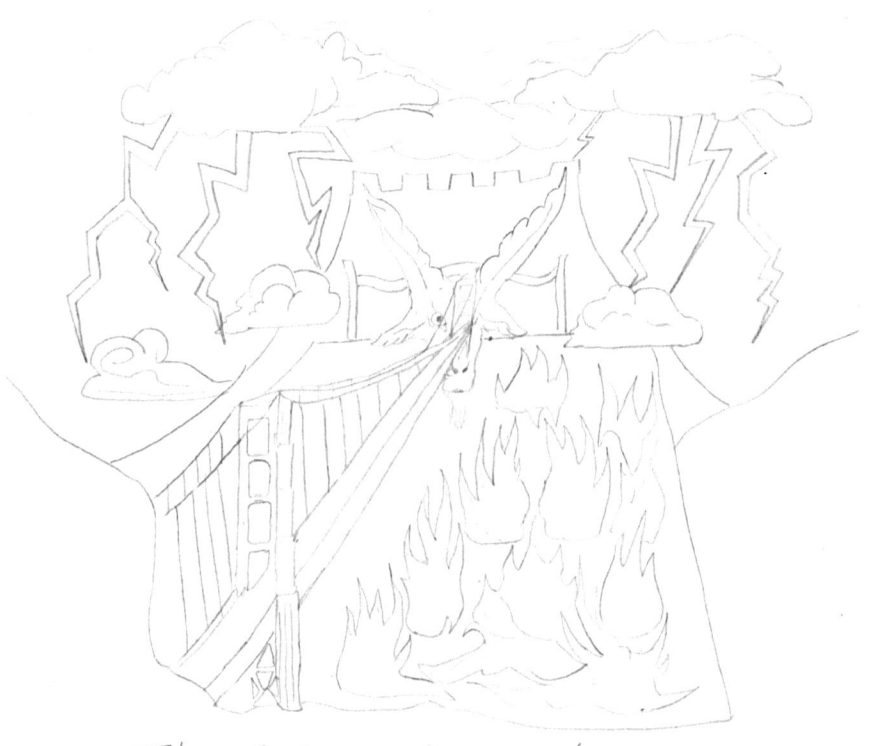

The Satanic Bay Bridge
Lucifer Jeremy White (Damuel)
12-30-39 AC

Lucifer Jeremy White
Lucifer Jeremy White

ALL PRAISE

Santa Muerte

Lucifer Jeremy White *Lucifer Jeremy White*
Lucifer Jeremy White *Lucifer Jeremy White*
Lucifer Jeremy White 12-30-39 AC Damuel.

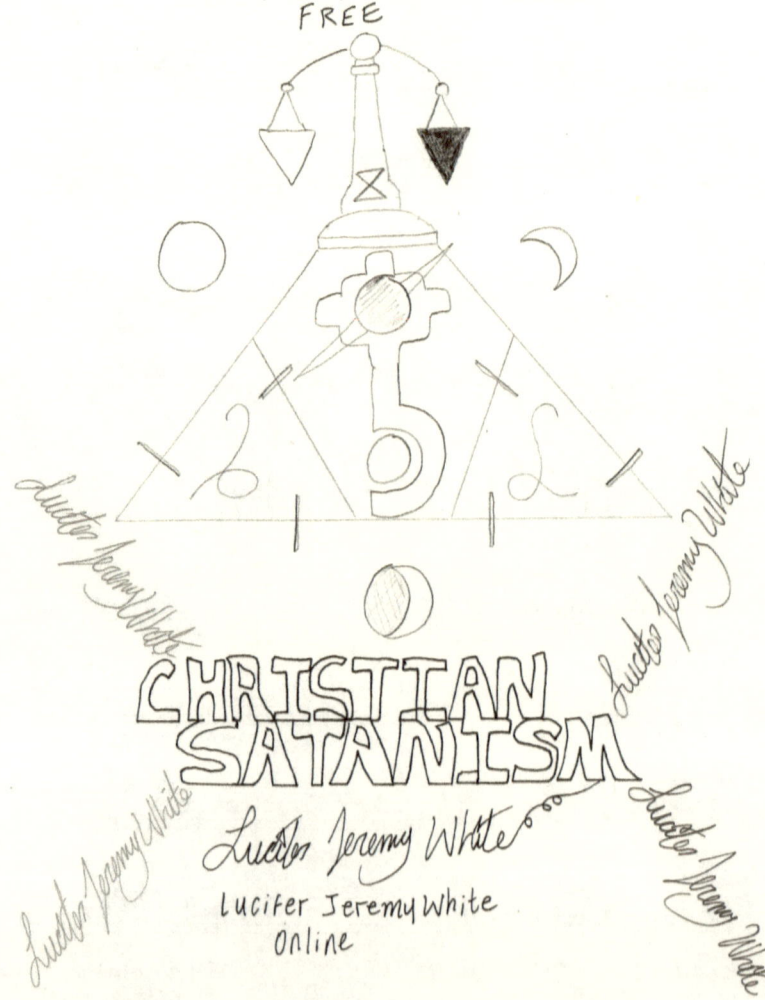

Samael

Lucifer Jeremy White
12-31-39 AC

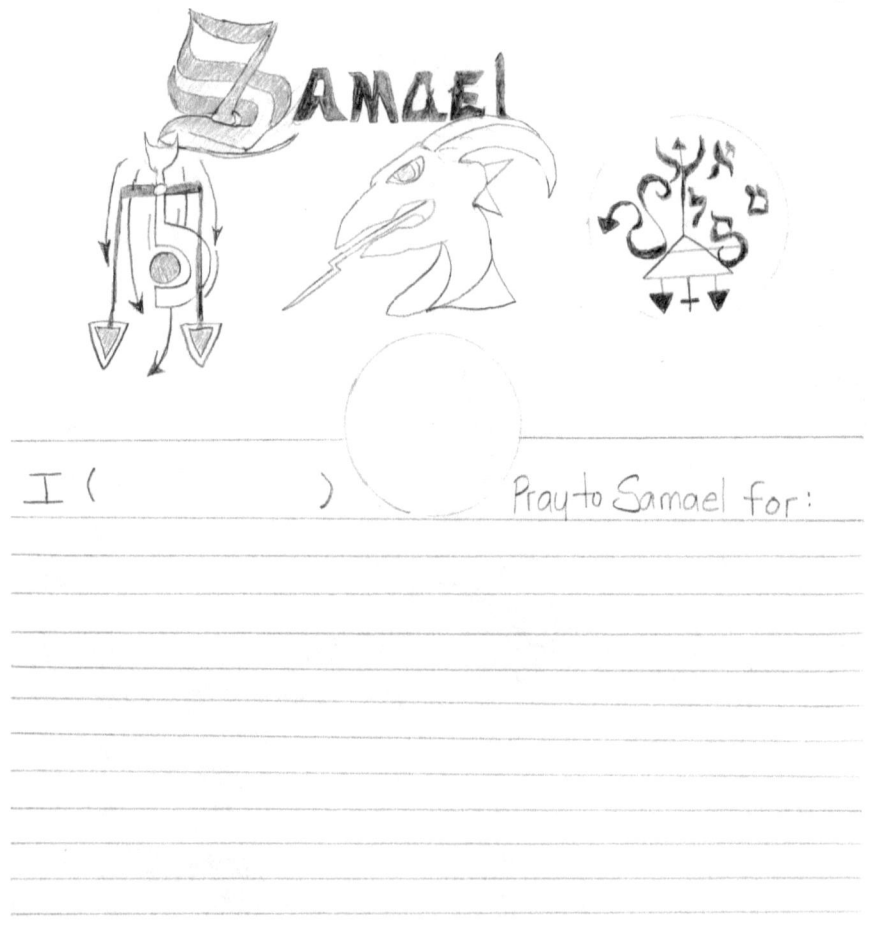

I () Pray to Samael for:

signed:

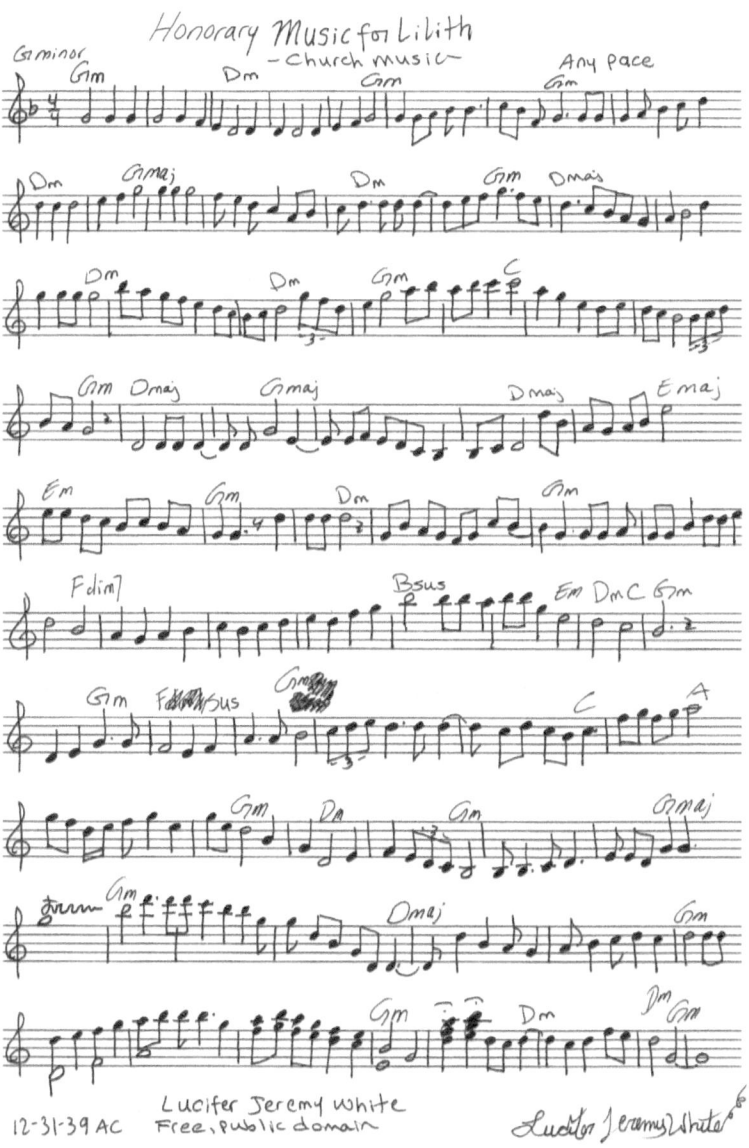

Lucifer Jeremy White Lucifer Jeremy White
Lucifer Jeremy White Lucifer Jeremy White
Lucifer Jeremy White
online

Damuel
1-1-39 AC
(Lucifer Jeremy White.)

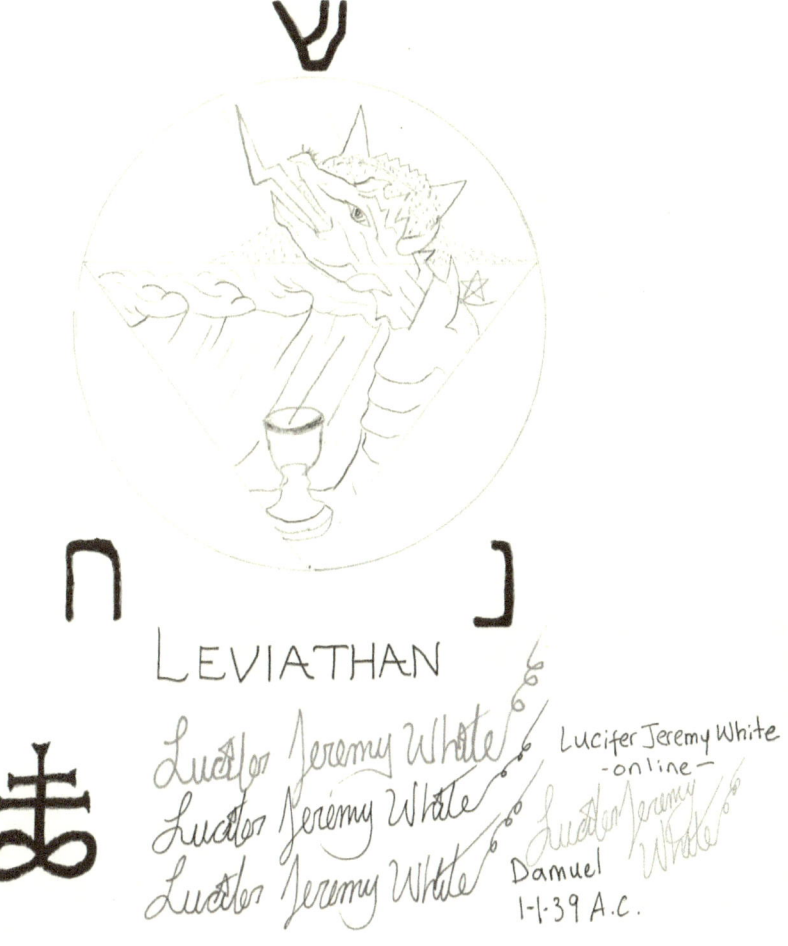

Aa Ll
Bb Mm
Cc Nn
Dd Oo Ww
Ee Pp Xx
Ff Qq Yy
Gg Rr Zz
Hh Ss
Ii Tt New Font
Jj Uu Satanica

New font "Satanica"

Lucifer Jeremy White

May Today **Y**ou

be

born

into

Darkness

Old name: _____

New name: _____
 date: _____

Lucifer's magic Language

	neutral (same)	weaker	stronger	Earth	Air	Water	fire	
A		β "ja"	ϟrä "rä"	♁ "ri"	♁ "ro"	♌ "iu"	♓ "ai"	Lucifer Jeremy White
B		⇃	β	△△	⇃	△△	⊿	
C		6	⊜	∞	⋈	⌒	⊂	
D		⌒	▷	F	⊠	Green	Red	
E		Ɛ "pa"	℮ı "sä"	⅔ "si"	Ψ "so"	⌒ "su"	∏ "as"	
F		∉	⨍	8	∞	⋶	A	
G		⌓	@	△	◇	▭	○	
H		☆	✡	⚶	△	▽	⊙	
I		⊓ "ma"	⅁ "Da"	β "Di"	ϒ "do"	♡ "du"	∀ "ad"	
J		7	⊤	⚛	Ⅲ	∞	⅂	
K		ɋ	⊬	†	○	⚷	Ψ	
L		⌞	⅄	⚓	⋈	✡	⌣	For the purposes of magical incantations and renderings
M		Π	u	⚲	⌇	m	⌒	Lucifer Jeremy White
N		⌒	⌦	⊓	⌁	⌐	⌐	
O		O "quä"	Ø "ca"	⋚ "kee"	μ "ko"	τ "ku"	⋈ "ak"	
P		(5) ∴	⌒	⋊	⋮⋮(6)	Ω	⌒↑	
Q		(1) .	(2) ..	(3) ∴	(4) ∷	⋈	♂	
R		2	℞	⋔	⫶	⌇	⫶	
S		⅃	5	⋈	ℼ	⊊	ℨ	
T		2	⋒	⌒	A	ε	I	
U		η "tä"	θ "La"	λ "lee"	Σ "lo"	Γ "lu"	Yellow "al"	
V		ⅉ	⟿	%	⚚	⊼	↗	
W		#	⟼	Ⅰ	⚓	⤓	⚔	
X		℞	⚷	⇒	⚓	♂	⚰	
Y		⊳ "ua"	ℍ "Ah"	φ "e"	ℕ "o"	⋈ "oo"	⋈ "ha"	Lucifer Jeremy White
Z		⇈	⌒	⌑	⌒	⋈	⌒	

"Finish the melody" Lucifer Jeremy White

G minor

Composer name: _____ Date: _____

My Promise to Satan:

Signed: _____ date: _____

Visualization Taste Magic

FORM

magic that mixes visualization and taste. Each taste represents something. Write down what they will mean.

Red food means:
Yellow food means:
Green food means:
Blue food means:
Brown food means:
Black food means:
White food means:
Orange food means:

Red food is for (person):	Or/And:
Yellow food is for:	
Green food is for:	
Blue food is for	
Brown food is for:	
Black food is for:	
White food is for:	
Orange food is for:	

Sugar is also for/means:
Salt is also for/means:
Bread is also for/means:
Meat is also for/means:
Dairy is also for/means:

Lucifer Jeremy White
Lucifer Jeremy White
Lucifer Jeremy White
Lucifer Jeremy White

A part of Christian Satanism. Lucifer Jeremy White.

Lucifer Jeremy White's
The Christian Satanic Rules of the
 Middle Grounds:
1. Repent against blasphemy to God.
2. Build up for yourself an excellent life.
3. Be a worldly person full of life.
4. Know your tastes and come to desire them.
5. Do not cuddle up to your fears.
6. Never commit a heinous act, an atrocity, anything evil.
7. Do not blaspheme against God, nor The Devil.
8. Prefer philanthropy over misanthropy.
9. If to be saved give your life to liberate the enslaved and down trodden.
10. Do not practice or promote atheism.
11. Do what you can to popularize and preserve Christian Satanism.
12. Do not be ~~pevert~~ perverted.
13. Do not start using drugs except for well-proven psychiatric drugs used to deter a negative condition.
14. Be a productive member of The Christian Satanic church even if you do not attend any services.
15. Give bountifully to the family you were born into unless you were abused by them.
16. Do not harbor hateful feelings toward God.

 Public Domain.

A Communion With Satan

You'll need: A pen — a fruit
A bowl — something sweet
sugar
water — Gather them together

1st Pluck a fruit from a tree and say "I take this in the name of Satan."

2nd Draw 666 on your eating hand and say "I take onto myself the number of The Beast. I accept this number."

3rd Dip your finger into the bowl of sugar water and touch between your eyes and say "May the serpent speak to me and hear what I say."

4th Dip the fruit into the sugar water and say "I eat this for wisdom and may pleasure enter into my life."

5th Eat the fruit then something sweet and say "What matters to me is pleasure."

Lucifer Jeremy White Lucifer Jeremy White
Lucifer Jeremy White Lucifer Jeremy White
Lucifer Jeremy White — Lucifer Jeremy White —
online
1-3-39 A.C.

Lucifer's Memory Program

Write down a memory for each word. Go for harder to remember things. You will recover many lost memories. The words:

1. Chain:
2. Balloon:
3. Ball:
4. Sunglasses:
5. Poster:
6. Toy:
7. Park:
8. Musical instrument:
9. Meeting:
10. Dive:
11. Seat:
12. Lock:
13. Lamp:
14. Book:
15. Tree:
16. Stars:
17. Hat:
18. Truck:
19. Cake:
20. Clock:

You are now a level one recaller. There are 98 more levels to go.

Lucifer Jeremy White
Lucifer Jeremy White

a Prayer to Beelzebub

I () pray to Beelzebub for:

Signed: _____

By Lucifer Jeremy White

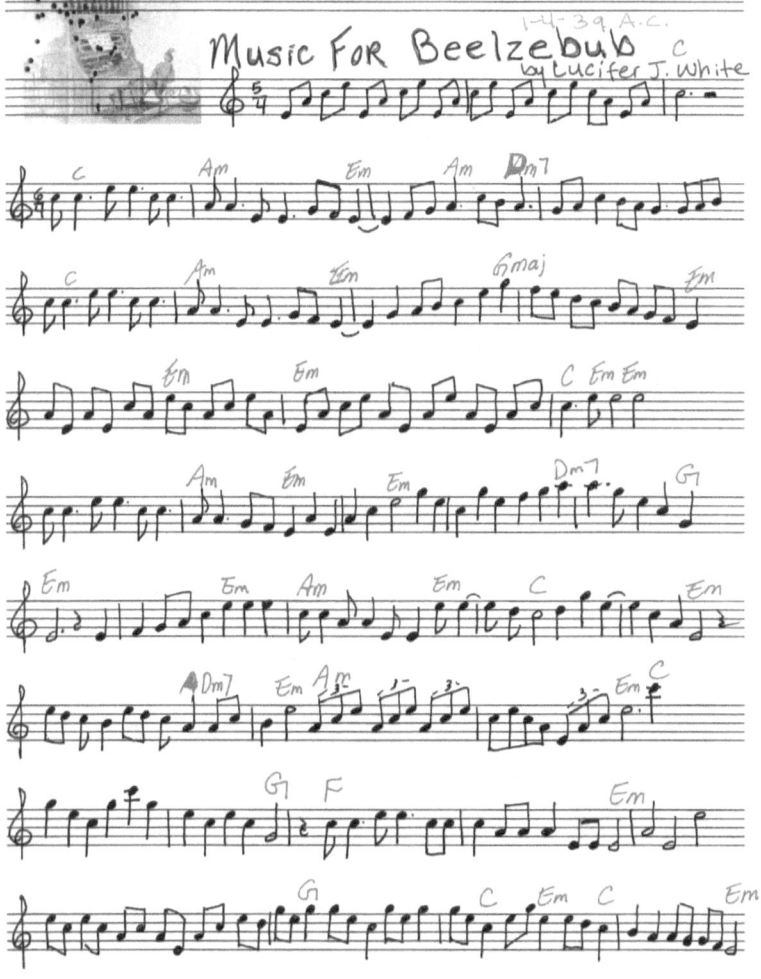

Music Videos

Lucifer Jeremy White Lucifer Jeremy White

Watch these Music Videos thinking of these Themes:

As Music from God to you:
Enya - Only Time; Alison Krauss - When you say nothing at all; open your Heart; Sade - By your side; Lisa Stansfield - All around the world; Lynn Anderson - I never promised you a rose garden; The Waterboys - Too Close to heaven; Bob Seger - Still the same; Sarah M. - In the arms of an angel; Pearl Jam - Black; GooGoo Dolls - Name; Paula Abdul - Cold hearted; The Police - Every Breath you take;

Music For God from you:
Fiona Apple - sleep to dream; No Doubt - it's my life; A.O.S - History repeats itself; Poe - Fly Away; Garbage - only happy when it rains; Garbage - As Heaven is Wide; Tory Amos - Crucify; Jethro Tull - Bungle in the Jungle; Jackson Brown - Doctor my eyes; Nelly Furtado - I'm like a bird; The Bangles - eternal flame; Ace of Base - The Sign; Garth Brooks - Friends in low places.

Music From/About Satan:
Journey - who's crying now; Malcom Mclaren - About Her (Kill Bill soundtrack); The Police - wrapped around your finger; Rihanna - Diamonds; Adele - Skyfall; Madonna - Lucky Star.

Lucifer Jeremy White 1-4-39 A.C.

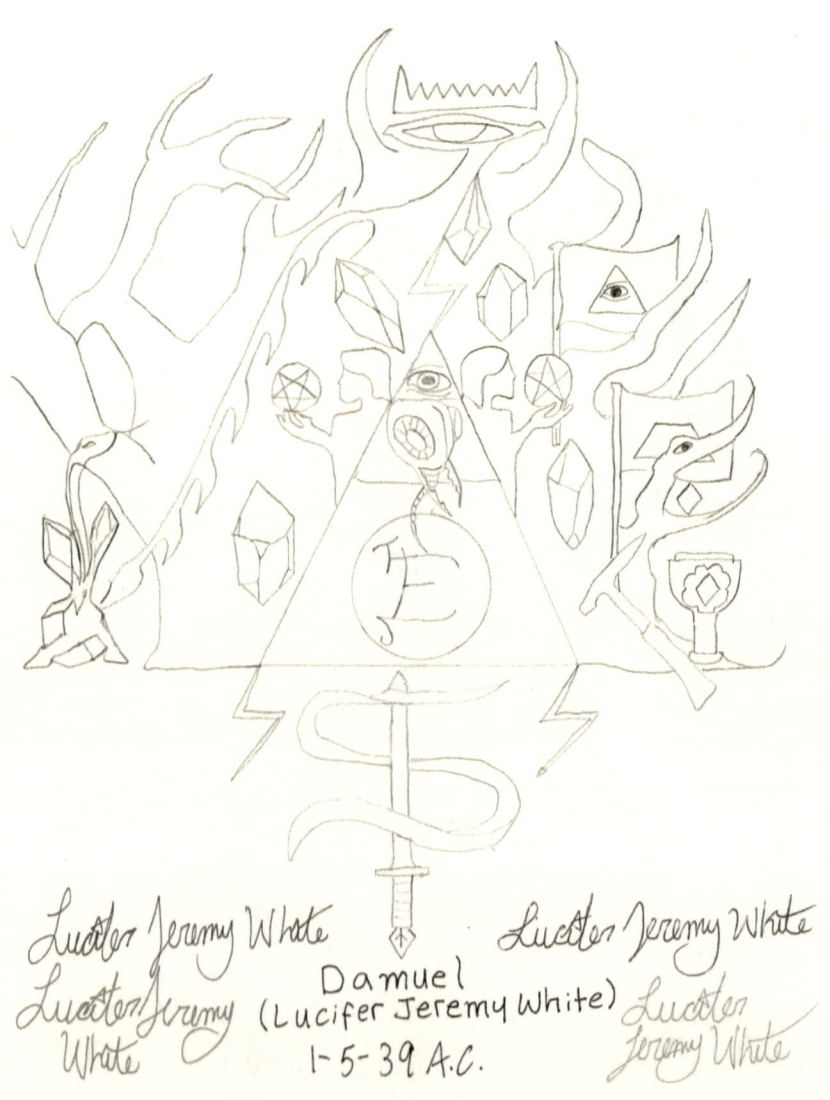

Design for an Idol of Satan

SATAN

Lucifer Jeremy White Lucifer Jeremy White Lucifer Jeremy White
Lucifer Jeremy White Lucifer Jeremy White Lucifer Jeremy White
Lucifer Jeremy White Lucifer Jeremy White Lucifer Jeremy White
White (online) White

Lucifer Jeremy White's CHRISTIAN SATANISM?!

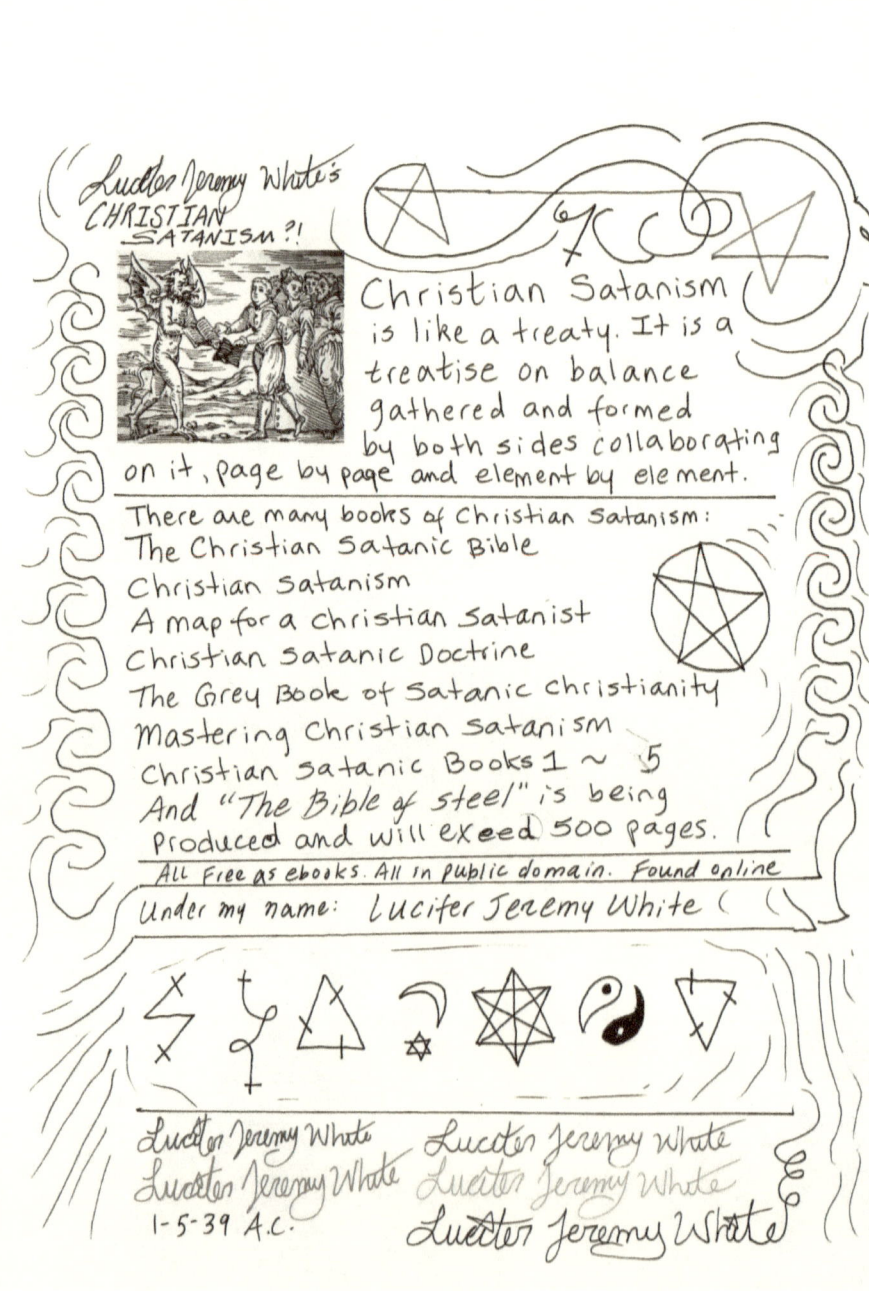

Christian Satanism is like a treaty. It is a treatise on balance gathered and formed by both sides collaborating on it, page by page and element by element.

There are many books of Christian Satanism:
The Christian Satanic Bible
Christian Satanism
A map for a christian Satanist
Christian Satanic Doctrine
The Grey Book of Satanic christianity
Mastering Christian Satanism
Christian Satanic Books 1 ~ 5
And "The Bible of Steel" is being produced and will exeed 500 pages.

All Free as ebooks. All in public domain. Found online under my name: Lucifer Jeremy White

Lucifer Jeremy White
Lucifer Jeremy White
Lucifer Jeremy White
Lucifer Jeremy White
Lucifer Jeremy White
1-5-39 A.C.

Beelzebub
Altar Design

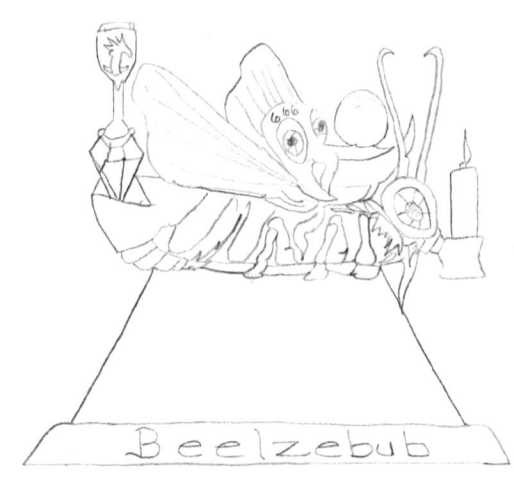

Lucifer Jeremy White

Lucifer's Memory Program

Remember and write down a memory for every word listed. Go for harder to remember things.

1. Desk
2. Rock
3. Box
4. Pole
5. Spray
6. Wrist
7. Water
8. Singing
9. Roof
10. Handle
11. Pouch/bag
12. Paint
13. Fence
14. Timer
15. Mirror
16. Porch
17. Insect
18. Climb
19. Call
20. Ride

You are now a Level 2 Recaller. There are 97 more levels to go.

— Lucifer Jeremy White

I worship
Goddess Aeon

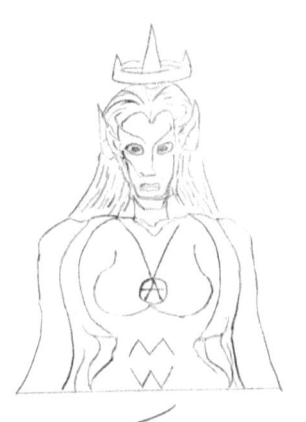

Lucifer Jeremy White
Lucifer Jeremy White
Lucifer Jeremy White
Lucifer Jeremy White
Lucifer Jeremy White
Lucifer Jeremy White
Lucifer Jeremy White
—online—

1-7-39 A.C.

Another Idol Design

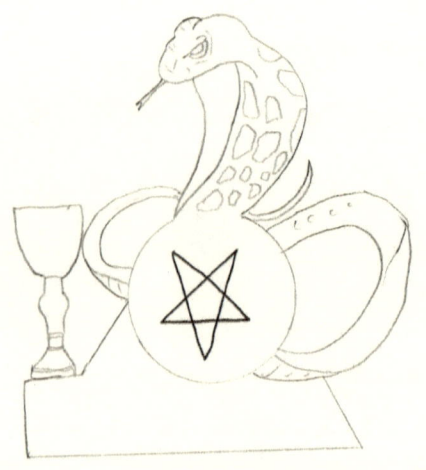

Lucifer Jeremy White

Design for
An Altar of
Lilith

Lilith

Lucifer Jeremy White
Lucifer Jeremy White
Lucifer Jeremy White

Lucifer Jeremy White
Lucifer Jeremy White
Lucifer Jeremy White
—online—

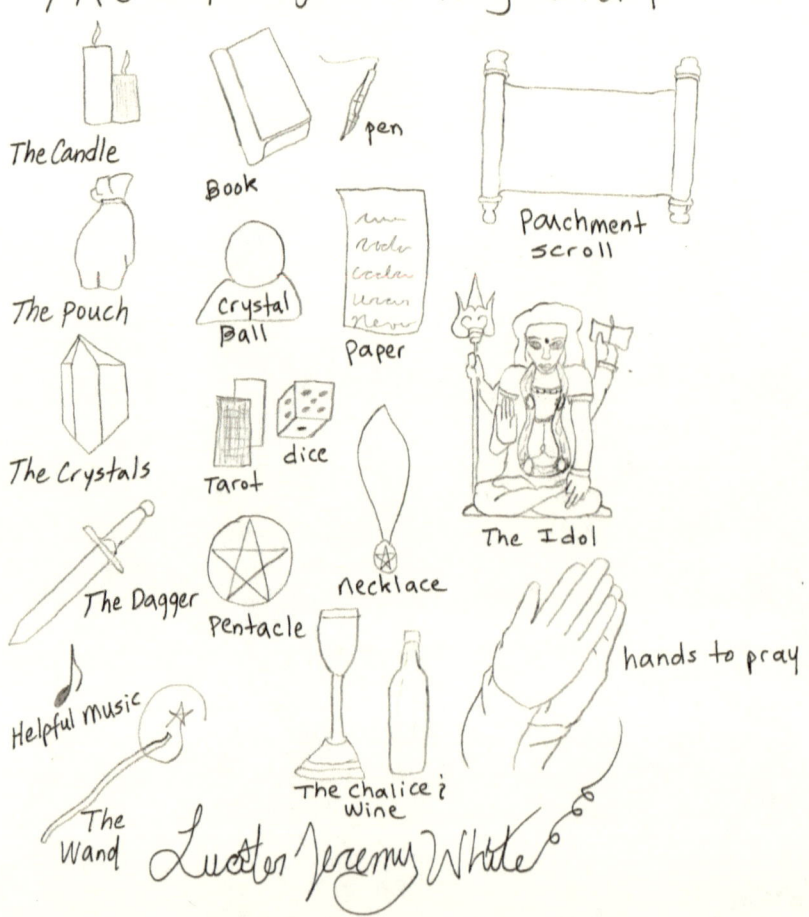

Lucifer's Crazy Ideas for Satanism

1. Worship the Star Bux logo. Use their cups as a chalice.
2. Use a devil-looking action figure or stuffed animal as an idol.
3. Be a Devil Worshiper in a childish way instead of an evil way — or be an evil kid.
4. Have a communion with the Devil but use candy and sugary drinks instead of wine and bread.
5. Turn regular music into satanic music using your imagination.
6. Do chores for the Devil — as a form of worship, a showing of dedication. Or do entire projects for him.
7. Publicly start a Satanic Church.
8. Go to a Catholic communion but privately honor Satan there instead

Lucifer Jeremy White
Lucifer Jeremy White
Lucifer Jeremy White
Lucifer Jeremy White

Lucifer Jeremy White (author) online.

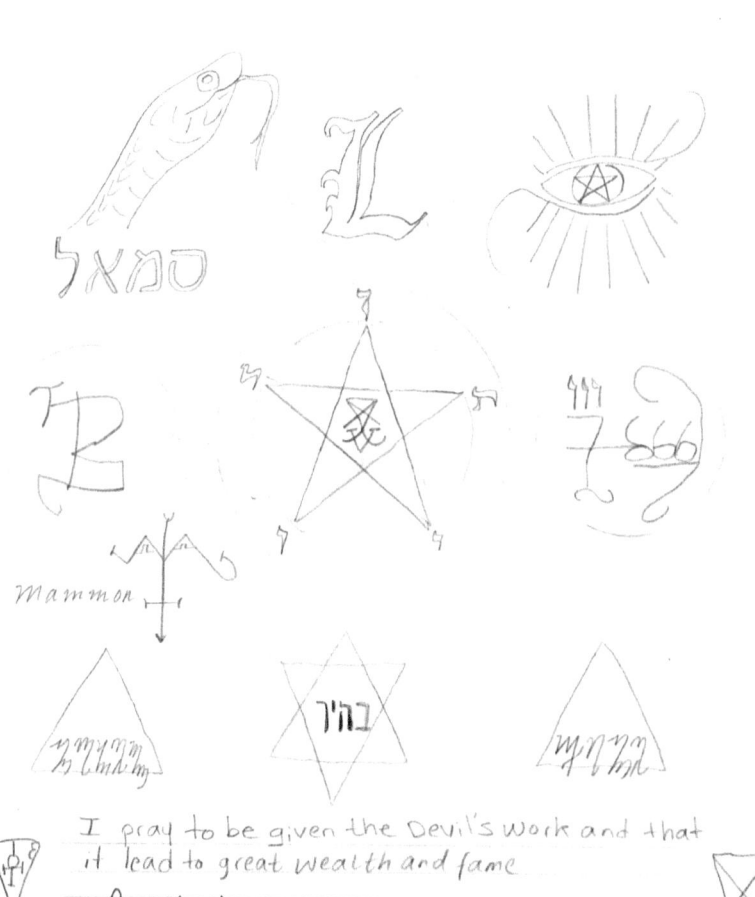

I pray to be given the Devil's work and that it lead to great wealth and fame

—Lucifer Jeremy White

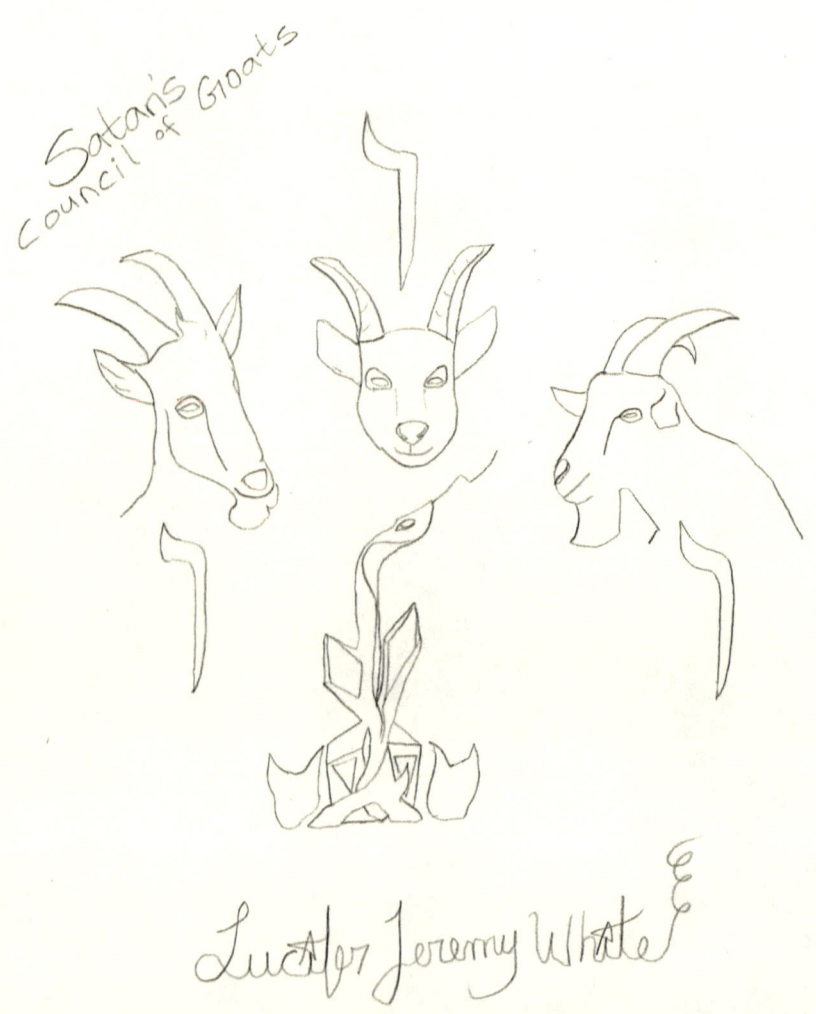

Beware the Jabberwock, my son!
The jaws that bite, the claws that
catch!

Lucifer White

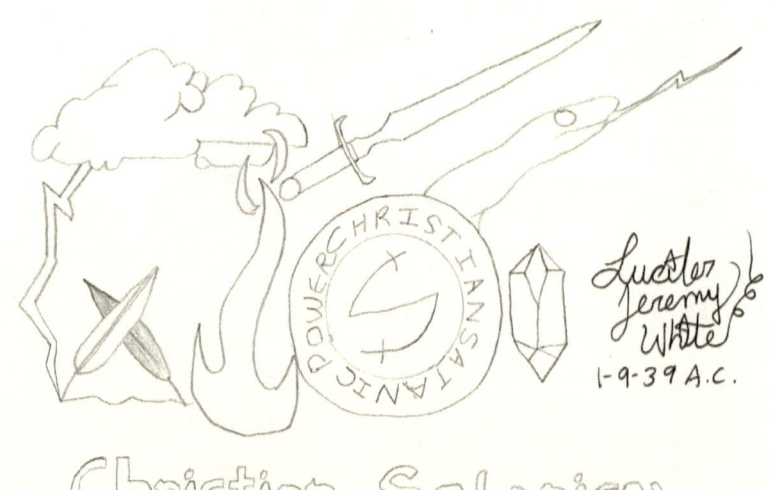

Christian Satanism
by Lucifer Jeremy White

I pray to the evil fairy

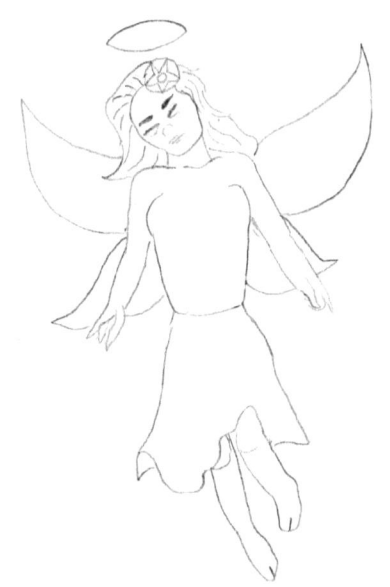

LJW

"Right and wrong are not what seperate us and our enemies. It's our different standpoints, our perspectives that seperate us. Both sides blame one another. There's no good or bad side. Just 2 sides holding different views." —Squall.

Revelations 22:16

I Jesus have sent mine angel to testify to you these things in the churches. I am the Root and the offspring of David, the Bright and Morning Star. †

Isaiah 14:12-14

How you are fallen from heaven, O Lucifer, son of the morning!

For you have said in your heart: 'I will exalt my throne above the stars of heaven, I will also sit on the mount of the congregation on the farthest sides of the north; I will ascend above the heights of the clouds, I will be like the most High."

— NKJV,

Lucifer Jeremy White *Lucifer Jeremy White*
Lucifer Jeremy White *Lucifer Jeremy White*

Grey-Things
Quotes for a Christian Satanist

The color of truth is gray
— André Gide

Most things in the world aren't black, aren't light, but most everything is just different. And now I know that there's nothing wrong with different, and that we can let things be different, we don't have to try and make them black or white, we can just let them be grey.
— By?

Life isn't black or white. It's a million gray areas, don't you find? — Ridley Scott

For grey matter, there is no black and white, then you do not use enough brain functions.
— Petek Kabakci

A grey day provides the best light
— Leonardo da Vinci

The loyal and most emerald
The tempted
By the moon's aging white
Never fell from grace
Never felt this gray
— Isbelle Razors

The truth is usually somewhere in the gray turbulent eddies set in motion by the mixture of black and white — Ken Poirot

Lucifer Jeremy White — online —

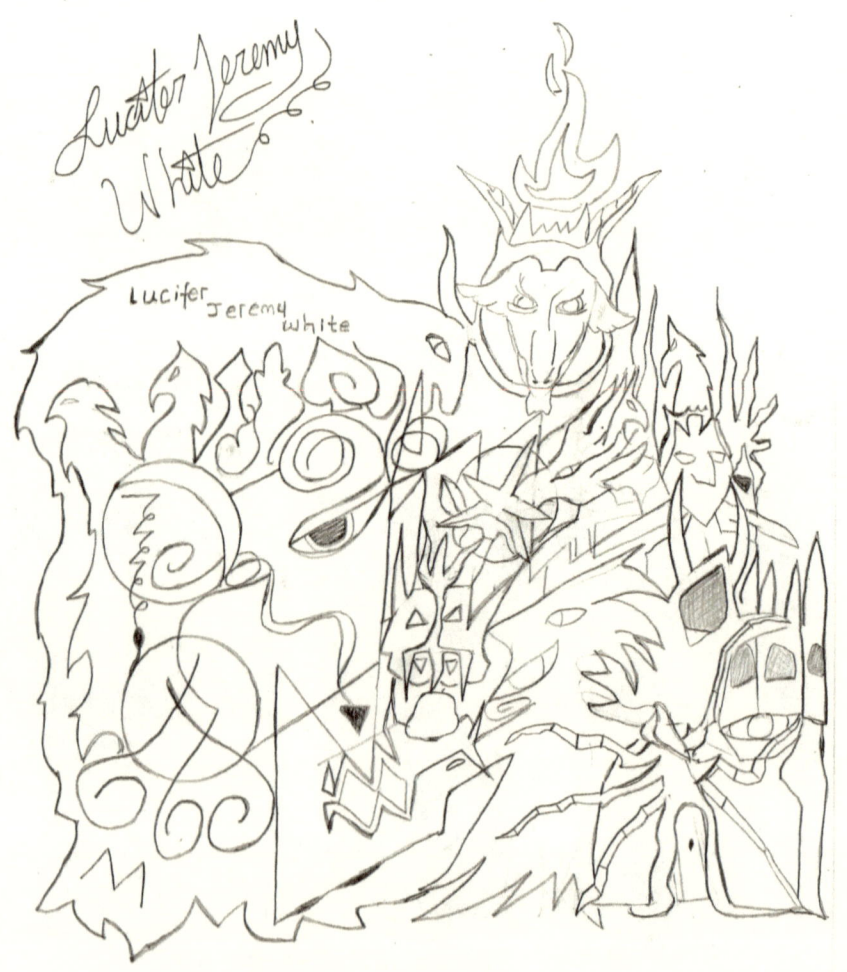

Celebration music for 80 or more members in a christian satanic church

Lucifer Jeremy White 1-10-39 A.C. Lucifer Jeremy White — online.

Lucifer's Memory Program

Remember something hard to remember based on every word. Here are the words:

1. Gate
2. Feather
3. Grass
4. Bottle
5. Loud
6. Spin
7. Run
8. Junk
9. Build
10. Rain
11. Disk
12. Sparkle
13. Crop
14. Salt
15. Push
16. Doll
17. Pass
18. Bag
19. Dishes
20. Energy

You are now a level 3 recaller. There are 96 more levels to go.

Lucifer Jeremy White

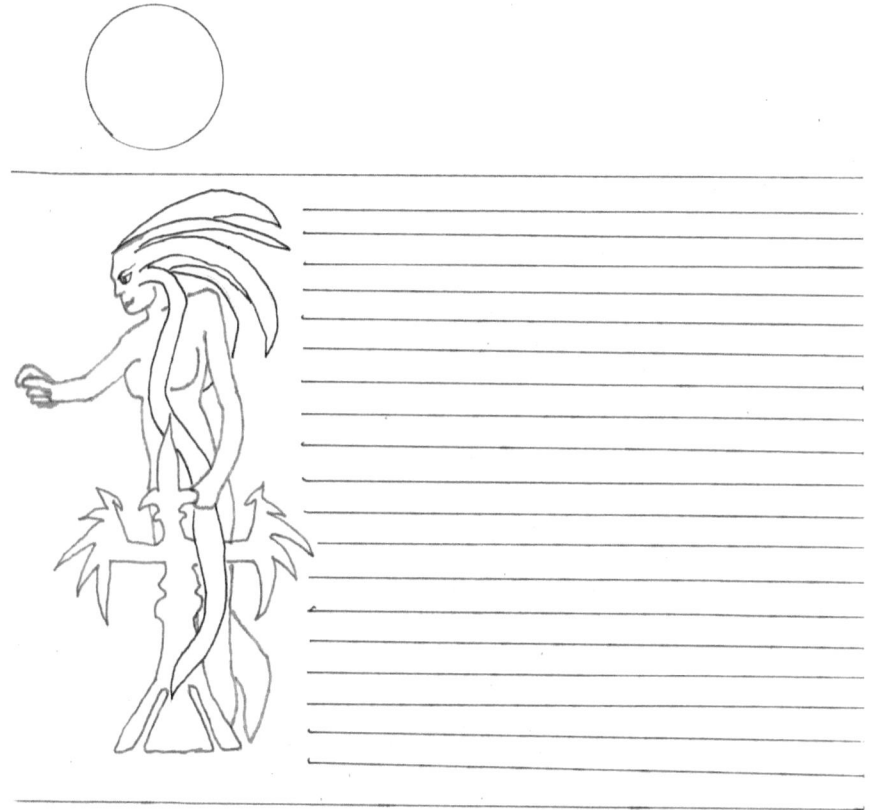

Shiva Prayer Sheet

LJW

A Message From Lucifer 1-10-39 A.C...

What is life about? For me it is about evolving. To make life better. Productively. To secure a better future. It's a lot about iced tea and self-thinking. Thinking of what I accomplished and what I may accomplish, as long as I start every day with that in mind, I'm sure I'll go far. I ride on the wings of destiny. It is a creature I've tamed. I hope to rest beside the greatest people. I know how much work that'll take. But I eagerly pursue it. My self talk regarding these things make me proud. I've written dozens of books — including this one. And I will continue to. I will go a long way for anything good. Doesn't have to be perfect. Just one step better and another, and another. I'm blessed to have been able to be the founder of Christian Satanism. In it I shine. I am perfect for it. Perhaps the gods know ~~say~~ so. Buying a scanner was the best thing I've done in a long time. For everything I can do by hand now I can produce a book from. I'm blessed with.. word processors, smartphones, paper, pens, pencils, and websites that distribute my books. Still, I haven't gotten yet the fame I desire. While I work all I need is iced tea beside me. So many books I've written. Will you check them out? They are all available under my name: ~~illegible~~ Lucifer Jeremy White, free as ebooks.

—LJW—

The Devil's Elixer

tea

RUM

St. John's wort

Ginko

Honey

Lucifer Jeremy White
Lucifer Jeremy White
—online—
1-10-39 A.C.

The Christian Satanic Emblem

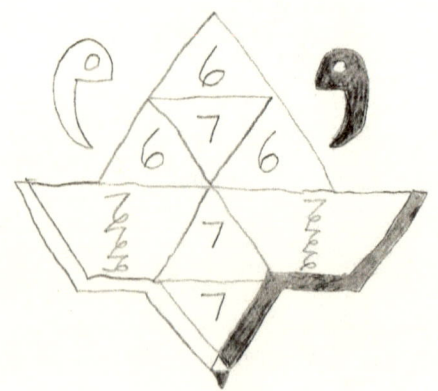

Lucifer Jeremy White

1-11-39 A.C.
(1-11-20)

by Lucifer Jeremy White

Lucifer's
Video Game Controller Idea

featuring Color changing light buttons

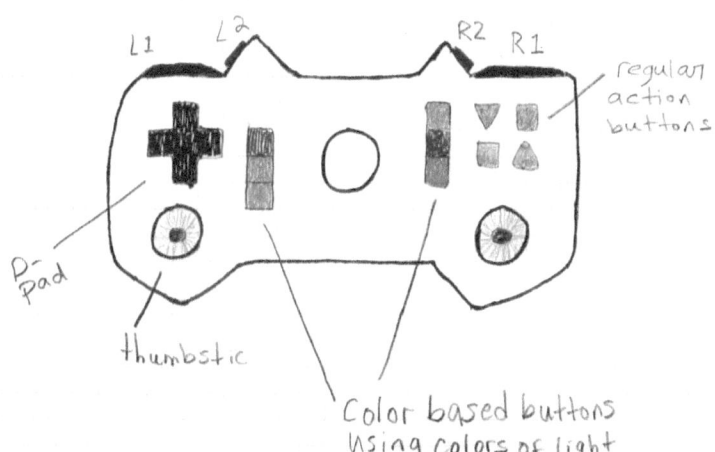

L1 L2 R2 R1

- D-pad
- thumbstick
- regular action buttons
- Color based buttons using colors of light

And the center circular button can be anything, perhaps having four lights, or just a home/start button.

by Lucifer Jeremy White (online.) Lucifer Jeremy White
Lucifer Jeremy White Lucifer Jeremy White Lucifer Jeremy White

Revelations 13:11 — Then I beheld another beast coming up out of the earth; and he had two horns like a lamb, and he spoke like a dragon.

Lucifer Jeremy White
Lucifer Jeremy White
-online-
Lucifer Jeremy White
Lucifer Jeremy White

My Palace In Hell

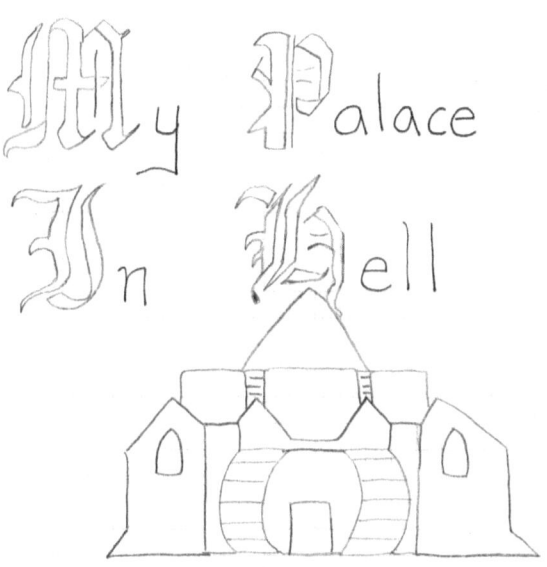

A palace of 5 sections. Each section the size of a small home. The first is just a main area in the center - it glows in the dark, its walls and things. It is a centralized area. The second is an area of tastes- of the things I most like, including food. The third section is a magic area loaded w/ magic tools, things to perform magic. The fourth is a memory section containing my memories, things of the past. And the fifth is a "master of expression" area. There I have all the things I need to fully express myself, such as creatively or writing, composing, etc. It is my palace in hell.

- Lucifer Jeremy White
 online.

Lucifer Jeremy White

All Praise Santa Muerte

Lucifer Jeremy White

1-11-39 A.C.

Christian Satanic Church Design

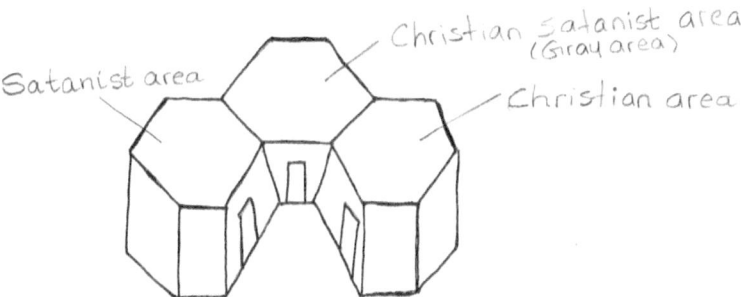

Satanist area — Christian Satanist area (Gray area) — Christian area

Lucifer Jeremy White Lucifer Jeremy White
Lucifer Jeremy White Lucifer Jeremy White
Lucifer Jeremy White Lucifer Jeremy White

Lucifer Jeremy White
—online—

[Lucifer Loves You!]

I ♡ Satan's

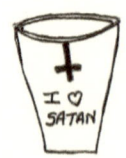

An idea for a resturant/drink place

Sign is a large (very large) star w/ digital imagry

Cups are satanic— w/ satanic symbols and art.

Plays metal music inside

And employees wear gothic-satanic things.

Lucifer Jeremy White

Lucifer Jeremy White - online -

The great octopus in the sky,
Visable from space

Lucifer Jeremy White
☆ online ☆

1-12-39 A.C.

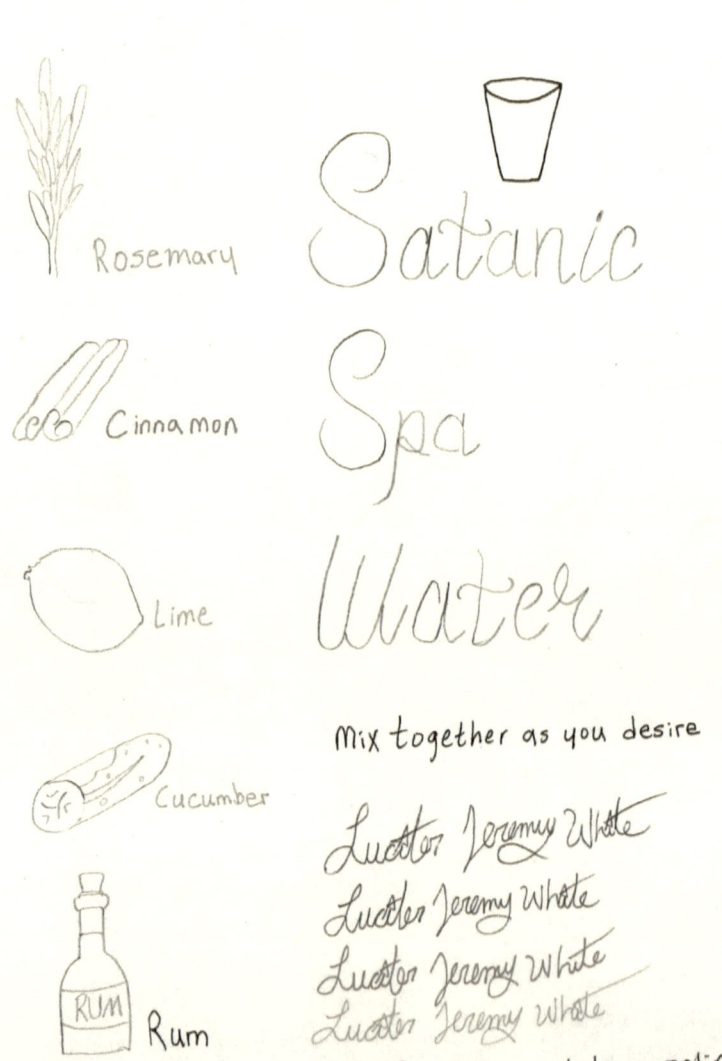

Satanic Spa Water

- Rosemary
- Cinnamon
- Lime
- Cucumber
- Rum

Mix together as you desire

Lucifer Jeremy White
Lucifer Jeremy White
Lucifer Jeremy White
Lucifer Jeremy White
Lucifer Jeremy White — online

Lucifer Jeremy White

A will-be-done

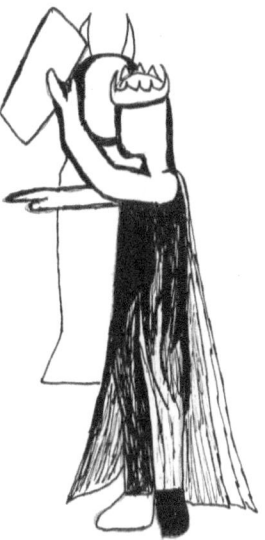

Ew! What an ugly mistake. Smashwords did not convert that stuff right. I'll have 2 uploads to fix. 2 more that is. I'm fairly confident that Lulu and the rest won't butcher things so badly. Will convert the file well enough.. hopefully. I've not ever done this in such a way. I'll continue doing my art books if they properly get created. We shall see, won't we? The work is not as hard as I make it to be. Am usually done rather quickly. Just 2.30 right now. I was done an hour ago. By the time I move out I may have up to 15 books done. Including some music comp books & the finishing of B.O.S. The thing is — once complete, always done/complete — no further work is needed. It is online forever. I gotta back up my files soon. After my first art book is done. 12 more images to go. I was hoping for this day, just recently. My first art book is nearly done.

If I get what I plan on doing done within a year my work may continue but it would have been enough for a lifetime.

Scanners are cheap, cheap enough to always have one.

Maybe someday I will be famous. A well known satanist. A well followed one. On YT talked about, and on TV. A person responsible for a great change in the world. World famous. Far above LaVey, whose group is stronger and much larger.

So that's the reason why I do what I do. To secure a better future.

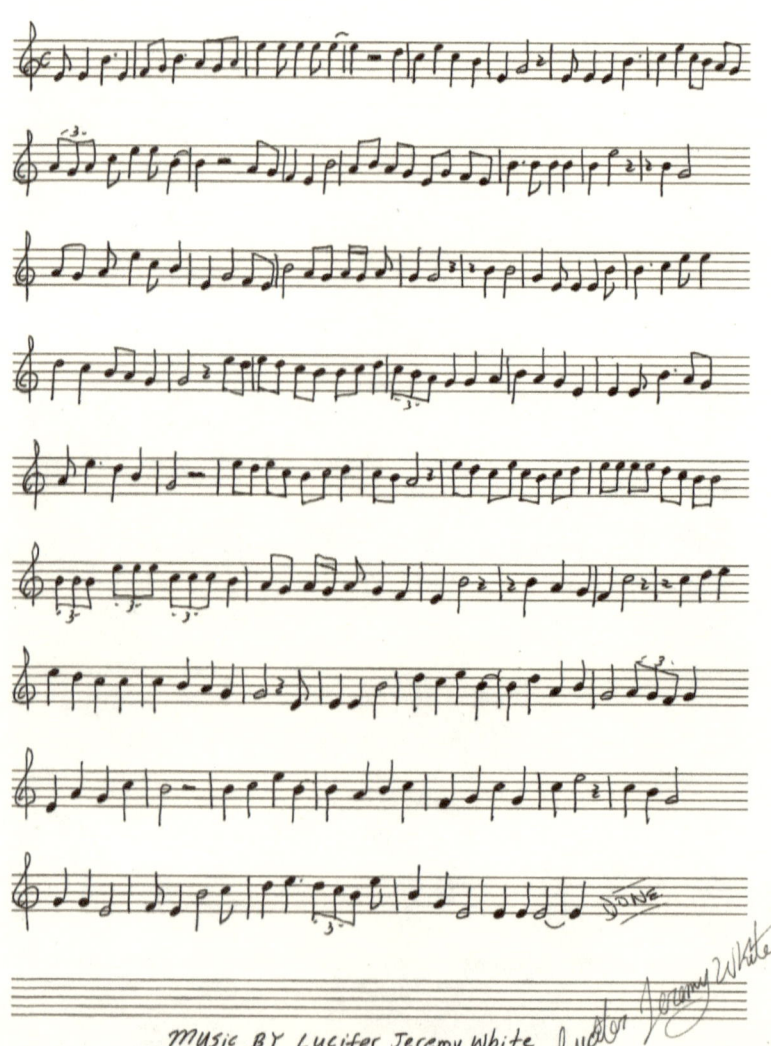

A Satanic Celebration

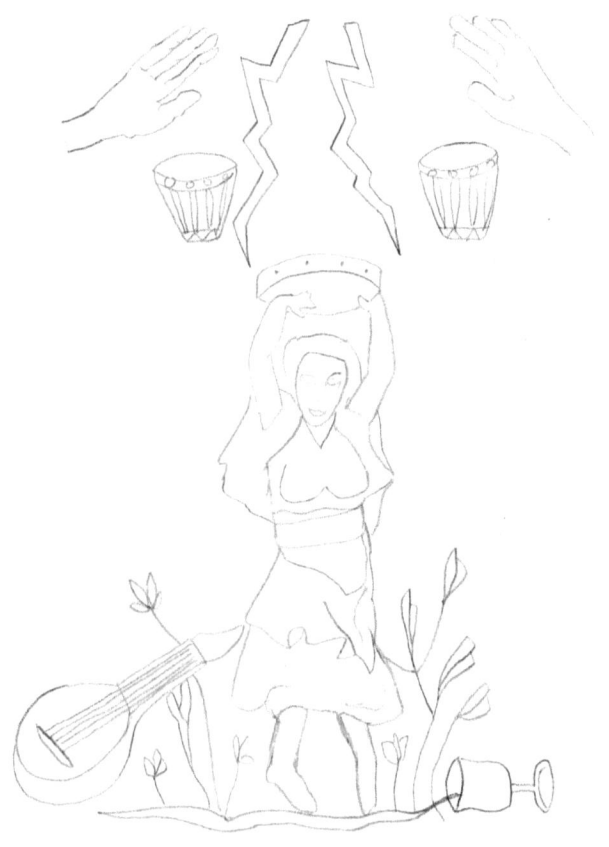

Lucifer Jeremy White

The Tower of Boom where the greatest reside, who are but a few.

Lucifer J. White

An Idea for a Satanic Software

The idea is for a witchcraft kind of software. A "magicians" kind of software.
Contains descriptions of demons. Symbols, sigils for them.
Lets you create magic papers from a template - containing sigils, symbols, circles, triangles, to fill in. And provides magical alphabets to type in.
Teaches the occult.
Has Tarot card readings implemented. And dice magic.
Has prayer sheets.
Contains images of demons.
Lots of printable stuff. Lets you create a Book of Shadows.
Herbal-magic, it teaches.
AI-created astrology readings.
Public domain occult books, perhaps.
Teaches ritual magic.
And other things like crystals, candles, spells, invocations.

— *Lucifer Jeremy White*
Lucifer Jeremy White *Lucifer Jeremy White*
Lucifer Jeremy White *Lucifer Jeremy White*
Lucifer Jeremy White
— online —

144-39 A.C.

Thank you for reading my book. I have worked long and hard on it. Yet I offer it in public domain. This book is in public Domain, voluntarily. So please share it and if you are able you may sell it, no problem. Am not so much after money. Am a person who would rather just make a difference.

I have written many books. 12 of them are about Christian Satanism. There is The Christian Satanic Bible, my first book. Then continuing onto books like "Christian Satanic Doctrine", "Mastering Christian Satanism," and simply "Christian Satanism," those teach Christian Satanism among 8 others. Am currently working on The Bible of Steel. Have done books on video Game ideas, too. They are all good books. 40 among them. They are all free too, and in public domain.. entirely.

Enjoy the art and stuff here. There's always more to come.

Your Friend,

Lucifer Jeremy White

1-14-39 A.C.

www.ingramcontent.com/pod-product-compliance
Lightning Source LLC
Chambersburg PA
CBHW021454210526
45463CB00002B/778